CW01368530

ATLAS
OF
The
Munsell Color System

Gift of
Walter C. Darnell
1973

Munsell, Albert Henry / Atlas of the Munsell color system

THE COLOR ATLAS.

THIS ATLAS CONSISTS OF TWO SETS OF CHARTS, ILLUSTRATING A SYSTEM OF COLOR MEASUREMENT OF WHICH THE FOLLOWING PARAGRAPHS GIVE A DESCRIPTION*

COLOR SPHERE AND COLOR TREE

VERTICAL AND HORIZONTAL CHARTS.

1. THREE COLOR SCALES UNITE IN A SPHERE.

Imagine a colored sphere with white as its north pole, black as its south pole, and its equator ringed about by a circuit of red, yellow, green, blue and purple hues—each of which melts imperceptibly into its neighbors. Fig. 1. Thus the equator traces the *horizontal scale of hues*: H

Imagine each equatorial hue as graded upward to white and downward to black in regular measured steps. Each hue then presents a scale of values over the surface, while the axis traces the *vertical scale of gray values*. V.

Imagine surface colors weakened by additions of neutral gray as they pass inward to disappear in the vertical axis. The sphere is thus filled with gradations of color,—lighter degrees above the equator, darker degrees below; stronger degrees outward, and weaker degrees inward to the axis, where all color is balanced in neutrality. This degree of color strength, at any point is known as *chroma* and is traced by radii at right angles to the axis. It represents the gradual emergence of each hue from grayness. Each radius serves as a *scale of chromas* C

Every color sensation may be measured and defined by these three scales of hue, value, and chroma. Neglect of either scale—that is, failure to state either the hue, the value, or the chroma of a color—creates doubt and confusion.

2. A COLOR TREE SURROUNDS THE COLOR SPHERE.

Were all pigment colors of equal chroma then a sphere would present an ideal of their relations. But pigments are very unequal in strength, Vermilion red, for example, being twice as strong as its opposite complement, blue-green Viridian. This is shown in chart 40. The unequal scales of pigment chroma may be treated as branches of a Color Tree whose trunk is the neutral axis, while its branches of various lengths and at various levels blossom out with the strongest colors. Thus the tree is imagined as compact of colored leaves—darker leaves below, lighter leaves above, most chromatic leaves on the surface and grayer leaves inward to the trunk, which is colorless. The tree also encloses the Color Sphere, which would appear were the longer branches lopped off to equal the length of the shortest branch. Fig. 2.

3. NOTATION OF COLORS BY SYMBOLS.

The place of each leaf of the Color Tree is determined by the measured scales of hue, value and chroma. These scales also furnish an expressive notation, made by the five color initials with their combinations and ten arabic numbers.

The scale of hue is a sequence of red (R), yellow-red (YR), yellow (Y), green-yellow (GY), green (G), blue-green (BG), blue (B), purple-blue (PB), purple (P), and red-purple (RP). The five principal hues melt imperceptibly into intermediates by ten steps, of which the middle or fifth step is typical of that hue. The scale of values is also decimal from 0 (black) to 10 (white), and the scale of chromas likewise from 0 (neutral gray) to 10 (the strongest permanent pigment so far obtained).

A symbol completely describing the character of any color sensation is composed of its degrees of hue, value, and chroma. The symbol for what is commonly known as Vermilion is $5R\frac{5}{10}$ ("five red, four over ten")—the numeral before R showing that it is the fifth or typical step of red in the hue scale, without tendency either to yellow-red or purple-red, the upper numeral showing that its luminosity equals the fourth step in the value scale, and the chroma numeral ten showing that it is of maximum strength. Chart H

Should the Vermilion be changed by fading or admixture with another pigment, this would appear in the symbol—thus a tinge of yellow in the red is written 6R while 4R indicates a tinge of purple, a slight addition of gray reduces the chroma to R_{8}, while the addition of white changes the value to R^{5}. Grouping all these changes in the symbol, $6R\frac{5}{8}$, shows that the original Vermilion $5R\frac{4}{10}$ is no longer pure, but tinged with yellow, lightened with white, and weakened with gray.

4. CHARTS OF THE COLOR SYSTEM.

The measured scales of hue, value and chroma are presented in two sets of charts, one made by vertical sections of the Color Tree, and the other by horizontal sections. Figs. 3 and 4.

There are eight vertical charts. Chart H is the hue scale arranged as an index for recording colors singly or in groups : Vermilion appears in the column R at the level four and with the chroma symbol ten. Chart V is the *value scale* upon a hinged and perforated card, behind which to test the value of a color sample. Thus Vermilion seen through the perforations is darker than value five and lighter than value three. It matches value step four. Chart C bears the *chroma scales* of red, yellow, green, blue and purple as tree branches whose levels and lengths describe the relation of these maxima to the extremes of white and black. Vermilion appears as the strongest red chroma, and the color is written $5R\frac{4}{10}$

The five remaining vertical charts are planes passed through the axis, on opposite sides of which appear the complementary fields of color. Chart R shows the red field with its complementary field of blue-green. By noting the symbol $5R\frac{4}{10}$ Vermilion may be balanced with any degree of its opposite blue-green. Chart Y shows yellow with its opposite purple-blue. Charts G, B, and P show green, blue, and purple with their appropriate complements, red-purple, yellow-red (orange), and green-yellow

There are seven horizontal charts. The axis appears on each as the neutral gray centre of a star or radial pattern, the lengths of whose radii indicate the chroma of their hues. These sections present colors at a single uniform level of value—thus, Chart 50 at the middle of the Color Tree bears only colors which reflect 50 per cent. of the luminosity of white, while Charts 40, 30, and 20 show darker levels, and Charts 60, 70, and 80 show the lighter levels of color.

5. BALANCE OF COLOR BY A SPHERE.

The sphere typifies balance of color.§ White and black balance at the centre on middle gray, N5. Balanced colors appear at the ends of any diameter passing through the centre of the sphere. Also, a lighter color balances a darker, but when unequal values or chromas are employed the color of weaker chroma must be given the larger area. The symbols on each step of these color charts indicate the proportions needed to produce balance, as suggested in the text to be found on each chart.

*For fuller information the reader is referred to the author's "A Color Notation", 3d edition, Boston, 1913. †Vermilion red, the sulphuret of mercury, is the most chromatic of permanent colors. ‡See Chapter VI of "A Color Notation."
§Models of A Color Tree and A Color Sphere have been designed to demonstrate the balance of color

COPYRIGHT, 1915, BY A H MUNSELL

MUNSELL COLOR SYSTEM

ATLAS
—of—
COLOR CHARTS.

COPYRIGHT BY A. H. MUNSELL 1907 1915
PATENTED JUNE 24, 1906

CHART

H

SCALE OF HUES

RP 9 8 7 6 P 4 3 2 1 PB 9 8 7 6 B 4 3 2 1 BG 9 8 7 6 G 4 3 2 1 GY 9 8 7 6 Y 4 3 2 1 YR 9 8 7 6 R 4 3 2 1 RP

SCALE OF VALUES

CHART H.
INDEX FOR COLOR NOTATION

This chart presents all color paths and records each step by a simple NOTATION. The ten steps of hue are written RP (red-purple), P (purple), PB (purple-blue), B (blue), BG (blue-green), G (green), GY (green-yellow), Y (yellow), YR (yellow-red or orange), and R (red).

Initials at the top of the chart trace the Sequence of Hues, numerals at the side trace the Sequence of Values, and the small numeral printed on each color step is an index of its Chroma i.e. strength or saturation. The color step made of vermilion bears the chroma numeral 10, it is at the value level 4, and at the red column R. This step is written 5R/4, or explained in a previous introduction and in chapter VI of "A Color Notation."

If this chart were bent around the equator of the color sphere forming a cylindrical envelope, it would contain a mercator chart of the globe, each hue taking the place of a meridian and each value level representing a parallel of latitude, while the chroma numerals would correspond to altitudes.

When the cylinder cut open on the red-purple meridian (RP) it would spread out to form this Hue Chart — green being at its center with yellow and red (warm hues) to the right, and the cool hues blue and purple to the left.

Colors shown on this chart have the irregular outside of the color tree, between which and the neutral gray trunk are the intermediate degrees of weaker chroma which appear on the succeeding charts H Y G B P and 20 30 40 50 60 70 80 of the system.

AVOID DUST, HANDLING AND EXPOSURE TO STRONG LIGHT

MUNSELL COLOR SYSTEM

ATLAS
—OF—
COLOR CHARTS.

COPYRIGHT BY A. H. MUNSELL 1907-1915
PATENTED JUNE 22, 1906.

CHART
V

White
10

N9

N8

N7

N6

N5

N4

N3

N2

N1

Black
0

Yellow

Green

Blue

Purple

Red

CHART V. AXIS of the color tree.

VALUE, i.e. the amount of light reflected from pigments, is the second dimension or quality of color, — the other two being HUE and CHROMA.

A scale of neutral or gray values extends from the extreme of whiteness (10) to the extreme of blackness (0), and is represented on this chart by the longest and padlocked card. The ruler at the side is readily found for sliding a facsimile of these perforations until a point is reached where the luminosity of the color matches that of a step in the gray scale. Should the color fall between two of these steps, the interval may be given decimally.

Thus the yellow has a value of eight (8) green is five (5) red and blue hue (4), purple three (3). Personal bias plays no part in this transverse scale of values. It is established by a special instrument adopted at the centre of optical measurements, in the Mass. Institute of Technology, and known as the Munsell Photometer.

These pigment colors vary not only in their VALUE, but also in their CHROMA, — as fully shown in Chart C, which explains why the color branches extending outward from the neutral axis are of unequal length. See chapters II and III of the teacher's handbook, "A COLOR NOTATION." (second edition.)

PROTECT THE CHART FROM DUST AND HANDLING.

MUNSELL COLOR SYSTEM

ATLAS
—OF—
COLOR CHARTS.

COPYRIGHT BY A. H. MUNSELL 1907-1915.

CHART
C

CHART C
CHROMATIC BRANCHES OF THE COLOR TREE

CHROMA, i.e. the strength of pigment colors, is the third dimension of color—the other two being HUE and VALUE.

Chroma is represented by the branches of the color tree, which extend outward from its neutral axis and bear the strongest colors at their extremities. These branches are of unequal length between charters ever in strength or saturation.

The chroma scale of red projects ten (10) steps outward from a neutral gray of the same value (/5), while green shows around 7, and purple and blue only 4 chromas. The shortest scale of yellow projects only (7) steps outward from a gray of that same value (8/), while that of blue must fall six (6) steps of chroma.

These scales are not due to personal bias or guess work, but have been scientifically established. They explain the unequal powers of pigments, showing how far the "warm hues" red and yellow, outbalance the "cold hues" blue and green. The circle struck from N5 is the surface of the color sphere, within which all colors are balanced.

Measured scales of VALUE and CHROMA make it possible to define a color with exactness. See chapter V. of the teacher's handbook, "A COLOR NOTATION." (second edition.)

PROTECT THE CHART FROM DUST AND HANDLING.

MUNSELL COLOR SYSTEM

ATLAS
COLOR CHARTS.

Copyright by A. H. Munsell 1907 1915
Patented June 26 1906

CHART
R

RED AND BLUE-GREEN CHART.

This chart presents a vertical plane passed through the axis of the color solid and bearing the complementary hues, red and blue-green. The pair of opposite hues is shown in regular measured scales from black to white, and from grayness to the strongest color made in stable pigments.

VALUES of red and blue-green range vertically from black (0) to white (10). CHROMAS or strengths of color range horizontally from neutral gray to the maximum (10).

Each step on these color scales bears an appropriate symbol describing its light and its strength. Thus R/5 a vermilion, the standard red of the system, which exhibits 100% of chromatic strength and reflects 40% of the incident light. In opposite BG/5 reflects the same percentage of light but only 50% of chroma. To balance this pair, the areas must be inversely as the chromas, s. e. since blue-green is but half as strong as vermilion red, twice as much is required for a balance. Attention to these measure leads to pleasing combinations.

Any chosen steps of red and blue-green upon this chart may be balanced by setting their symbols... thus light blue-green (BG 7) balances dark red (R4) when the areas are inversely as the product of the symbols viz. six parts of light blue-green and twenty-four parts of dark red.

Chapters III and IV of the handbook "A Color Notation," describe these balances and their combinations with other hues. The symbol on each color step is its NAME, a measure of its light and strength by which it is to be measured, written and reproduced.

AVOID DUST, HANDLING AND EXPOSURE TO STRONG LIGHT

MUNSELL COLOR SYSTEM

ATLAS
— OF —
COLOR CHARTS.

COPYRIGHT BY A. H. MUNSELL 1907 1915

CHART
Y

YELLOW AND PURPLE-BLUE CHART.

AVOID DUST, HANDLING AND EXPOSURE TO STRONG LIGHT.

MUNSELL COLOR SYSTEM

ATLAS
COLOR CHARTS.

COPYRIGHT BY A. H. MUNSELL, 1907-1915
PATENTED JUNE 20, 1906

CHART

G

SCALE OF VALUES

SCALE OF VALUES

SCALE OF CHROMAS

GREEN AND RED-PURPLE CHART.

This chart presents a vertical plane passed through the axis of the color solid and bears the complementary hues, green and red-purple. This pair of opposite hues is shown in regular measured scales from black to white and from grayness to the strongest color made in stable pigment.

VALUES of green and red-purple range vertically from black (0) to white (10). CHROMAS or strength of color range horizontally from neutral gray to the maximum (10).

Each step in these color scales bears an appropriate symbol describing its light and its strength. Thus G5 is emerald-green, the strongest permanent green, which exhibits 70% of chromatic strength and reflects 50% of the incident light. Its opposite RP5 reflects the same percentage of light but only 60% of chroma. To balance this pair the areas must be inversely as the chromas, i. e., since

red-purple is one seventh less strong than green, seven parts of red-purple will balance six parts of the green. Attention to these measures leads to pleasing combinations.

Any chosen steps of green and red-purplecan the chart may be balanced by seeing their symbols, thus light green (G1) balances dark red-purple (RP1), when the areas are inversely as the product of the symbols viz., forty parts of dark red-purple and four parts of light green.

Chapters III and IV of the handbook, "A Color Notation," describe these balances and their combinations with other hues. The symbol on each color step is its NAME, a measure of its light and strength by which it is to be memorized, written and reproduced.

AVOID DUST, HANDLING AND EXPOSURE TO STRONG LIGHT

MUNSELL COLOR SYSTEM

ATLAS
COLOR CHARTS.

CHART
B

BLUE AND YELLOW-RED CHART.

AVOID DUST, HANDLING AND EXPOSURE TO STRONG LIGHT

MUNSELL COLOR SYSTEM

ATLAS
—OF—
COLOR CHARTS.

Copyright by A. H. Munsell 1907-1915
Patented June 20, 1906

CHART

P

SCALE OF VALUES

SCALE OF CHROMAS

PURPLE AND GREEN-YELLOW CHART.

This chart presents a vertical plane passed through the axis of the color solid and bears the complementary hues, purple and green-yellow. This pair of opposite hues is shown in regular measured series from black to white and from grayness to the strongest color made in stable pigment.

VALUES of purple and green-yellow range vertically from black (0) to white (10) CHROMAS or strengths of color range horizontally from neutral gray to the maximum (10).

Each step in these color scales bears an appropriate symbol describing its light and its strength. Thus P4/6 is a compound purple, the strongest permanent color, which exhibits 50% of chromatic strength and reflects the same amount of light as N 4/ of the value scale. Its opposite GY 4/6 reflects the same amount of light but only 50% of chroma. To balance

this pair the areas must be inversely as the chromas, i. e., since green-yellow is one-tenth less strong than the purple, its parts of green-yellow will balance five parts of the purple. Attention to these measures leads to pleasing combinations.

Any chosen steps of purple and green-yellow upon this chart may be balanced by noting their symbols; thus light green-yellow (GY8/4) balances dark purple (P4/), which the eyes are instantly aware of the symbols, ten-one parts of light green-yellow and forty-eight parts of dark purple.

Chapters III and IV of the handbook, "A Color Notation," describe these balances and their combinations with each other hues. The symbol on each color step is its NAME, a measure of its light and strength by which it is to be memorized, written and reproduced.

AVOID DUST, HANDLING AND EXPOSURE TO STRONG LIGHT

MUNSELL COLOR SYSTEM

ATLAS
—of—
COLOR CHARTS.

COPYRIGHT BY A. H. MUNSELL, 1907-1915.
PATENTED JUNE 24, 1906.

CHART 20

CHART 20.
DARK SCALES OF HUE AND CHROMA, REFLECTING 20% OF THE INCIDENT LIGHT.

The chart is a horizontal section through the color solid, similar to chart 50 except that the shorter radii describe a loss of chroma as colors darken.

Each radius from the neutral center, N¹, is a scale of chroma for its hue and displays the strongest obtainable stable pigment at this level. Each step on the scale bears its appropriate symbol by which the color is known and written. For simplicity the suffix is given but equal and measured steps, so that the symbol B¹ indicates that this particular dark blue reflects 20% of standard white and 40% of the strength of the maximum standard variation.

To balance any pair of opposite colors on this chart, such as B¹ and YR¹ (look around the area of each color should be inversely as its chroma, i. e., four parts of YR¹ with one part of B¹.

To balance this dark B¹ with its corresponding light YR¹ (orange), on chart 80 the area of each should be inversely as the product of its symbol, thus eight parts of the light orange balance forty parts of dark blue.

The suggestions for selecting sequences and groups of color which appear on chart 50, are also applicable here, as indicated in Chapters III and IV of the hand book, "A Color Notation."

AVOID DUST, HANDLING AND EXPOSURE TO STRONG LIGHT.

MUNSELL COLOR SYSTEM

ATLAS
—OF—
COLOR CHARTS.

COPYRIGHT BY A. H. MUNSELL 1907-1915
Patented Jan. 28, 1906

CHART
30

CHART 30.
DARK VALUE SCALES OF HUE AND CHROMA.

This chart is a horizontal section through the color solid, similar to that of chart 50 except that all its colors reflect but 20% of the incident light.

Each radius is a scale of chroma, whose steps appear written beneath the line. Thus R_5 is the strongest step of red and reflects 20% of the stimulus of standard vermilion. Its opposite hue—blue-green, has but four steps of chroma at this level and so balances these stronger chromas, the area of the weaker need be seven fourths as great as that of the stronger color.

Each successive circle traces hues of equal chroma. A sequence of regularly decreasing chromas may be traced thus — $P5$, RP_4, YR_3, GY_2, $N1$. The suggestions on chart 50 may be applied to this chart as indicated in chapters III and IV of "Color Notation."

AVOID HANDLING AND EXPOSURE TO DUST.

MUNSELL COLOR SYSTEM

ATLAS
—OF—
COLOR CHARTS.

COPYRIGHT BY A. H. MUNSELL, 1907-1915.
PATENTED JUNE 29, 1909.

CHART 40

CHART 40.
SCALES OF HUE AND CHROMA, REFLECTING 40% OF THE INCIDENT LIGHT.

This chart is a horizontal section through the color solid, similar to chart 39 except that all its colors reflect 40% less light. It will be noticed by comparison that the weakness the yellow field, while the field of purple-blue is greatly increased.

Each of the ten hues exhibits its scale of chroma on a radius from the neutral center (N5) to the strongest color obtainable in stable pigment. Thus YR, Y and GY, extend only to the fifth or middle step of chroma, while the powerful PB projects nearly twice as far in it.

To balance the unequal chromas of any opposite pair, the areas must be proportioned to the symbols printed on the cakes: thus nine parts of Y5 balances five parts of PB5. Each concentric circle traces equal steps of chroma through the ten hues, and the suggestions for making color sequences which appear on the other charts apply here also. See Chapters III and IV of "A Color Notation"

AVOID DUST, HANDLING AND LONG EXPOSURE TO THE LIGHT

MUNSELL COLOR SYSTEM

ATLAS
OF
COLOR CHARTS.

COPYRIGHT BY A. H. MUNSELL 1907 1915
PATENTED JUNE 28 1908

CHART 50

CHART 50
MIDDLE VALUE SCALES OF HUE AND CHROMA

This Chart is a horizontal section through the center of the Color Solid, classifying all values of MIDDLE VALUE, by transverse scales of HUE and CHROMA.

Each radius is a SCALE OF CHROMA starting from the neutral center N5. It traces a regular increase in the chroma of its pigment hues, and bears appearance symbols. Thus R5 indicates that the red upon which it is placed reflects 50% of standard white and 90% of the strength of standard vermilion.

Each circle struck from the neutral center is a SCALE OF HUE. It is a circuit of ten measured hues, equal in value and chroma. This equality appears in their symbols, — R5, YR5, Y5, GY5, G5, BG5, B5, PB5, P5 and RP5 which is a balanced circle of hues reflecting 50% of standard white and 50% of the chroma of standard vermilion.

A BALANCE of opposite hues which complement and enhance one another, is obtained by equal areas of equal chroma — such as BG5 and R5 — or by compensating areas of unequal chroma, such as lesser parts of BG5 with less parts of R5.

A SEQUENCE of successive hues combined with increasing chroma in equal additions is traced thus:- D1, C2, Y3, B4, or the differences may be doubled thus P1, C3, Y5. In short, the qualitative and quantitative constitution of this chart by measured intervals, creates an orderly succession of colors, and any scheme, — regular or irregular — at some product in the written symbols. See Chapters III and VI of "A COLOR NOTATION," by the author, which describes the nature and use of these charts.

AVOID HANDLING and EXPOSURE TO LIGHT or DUST.

MUNSELL COLOR SYSTEM

ATLAS
COLOR CHARTS.

CHART
60

CHART 60.
SCALES OF HUE AND CHROMA, REFLECTING 65% OF THE INCIDENT LIGHT.

AVOID DUST, HANDLING AND LONG EXPOSURE TO LIGHT

MUNSELL COLOR SYSTEM

ATLAS
—of—
COLOR CHARTS.

COPYRIGHT BY A. H. MUNSELL, 1907-1915
PATENTED FEB. 23, 1906.

CHART 70

CHART 70
LIGHT VALUE SCALES OF HUE AND CHROMA.

This chart is a horizontal section through the color solid, similar to that of chart 50 except that all of its colors reflect 7/12 of the in-door light.

Each radius is A SCALE OF CHROMA starting from the neutral center N/5. Distance a regular increase of strength as its pigment has, and each one bears an appropriate symbol. Thus 8/5 indicates that the red upon which it is placed, unites seven-tenths of standard white and six tenths of standard vermilion. In opaque or transparent, blue-green (BG) is slightly weaker at this level, as appears in the central 5 termini below that five, and 6 below white put, six tenths of blue green should be used with five tenths of the red.

Each concentric circle bears hues of uniform chroma; the two inner circles being complete with ten STEPS OF HUE, which are written R, YR, Y, GY, G, BG, B, PB, P, RP; showing that both value and chroma are equal.

The third circle is incomplete for want of a purple-blue. In the fourth circle six neighbor purple is also missing. The fifth circle has no representatives from blue-green to red in the sixth blue-green disappears, the seventh only presents green, yellow green, yellow and yellow-red, while the eighth circle is represented by yellow alone.

These tests describe the unequal strength of pigments at the level of the color solid and should be compared with chart 50 where the relations of strength and weakness are inverted.

For a study of balance and sequence on this chart see Chapters III and IV of "A Color Notation" by the author.

AVOID HANDLING AND EXPOSURE TO DUST

MUNSELL COLOR SYSTEM

ATLAS
—OF—
COLOR CHARTS.

COPYRIGHT BY A. H. MUNSELL 1907-1915
PATENTED JUNE 26 1906

CHART 80

CHART 80.
LIGHT SCALES OF HUE AND CHROMA, REFLECTING 80% OF THE INCIDENT LIGHT.

This chart is a horizontal section through the color solid, similar to chart 30 except that the relative chromas change at their hues approximate to white.

Each colors from the neutral center, N5, is a scale of chroma for its hue and displays the strength obtainable in stable pigment at this level. Each step in the scale bears an approximate symbol by which the color is known and written. For simplicity the chroma scale is given in equal and measured steps, so that the symbol Y⅝ shows that this strong yellow reflects 80% of the incident light and 99% of the strength of the maximum standard varnish.

To balance any pair of opposite colors on the chart, such as B⅝ and YR⅝ (light orange), the area of each color should be inversely as its chroma, i. e., two parts of YR⅝ with five parts of B⅝.

To balance Y⅝ which is a very light and chromatic, with its dark complement PB⅝ on chart 20 which is of weak chroma, requires that the area of each be inversely as the product of its squared, thus four parts of the powerful yellow balance seventy-two parts of the dark blue.

The suggestions for selecting sequences and groups of color which appear on chart 30, are also applicable here, as indicated in Chapters III and IV of the handbook "A Color Notation."

AVOID DUST, HANDLING AND EXPOSURE TO STRONG LIGHT.

ND1492.M96a c.2 MSC
Munsell, Albert Henry
Atlas of the Munsell Color
System.

DATE OUT	ISSUED TO

Lightning Source UK Ltd.
Milton Keynes UK
UKHW022024091221
395394UK00006B/1437